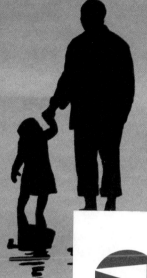

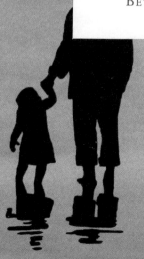

LIFE
with Father

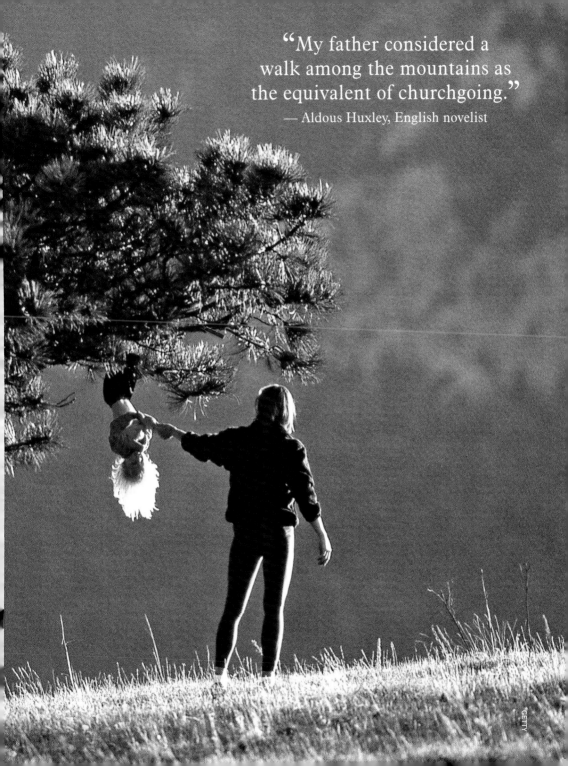

"My father considered a walk among the mountains as the equivalent of churchgoing."
— Aldous Huxley, English novelist

LIFE Books

EDITOR Robert Sullivan
DIRECTOR OF PHOTOGRAPHY
Barbara Baker Burrows
DEPUTY PICTURE EDITOR
Christina Lieberman
CREATIVE DIRECTOR Michael Roseman
COPY CHIEF Barbara Gogan
COPY Danielle Dowling, Parlan McGaw
PHOTO ASSISTANT Forrester Hambrecht
REPORTER Hildegarde Anderson

PRESIDENT Andrew Blau
BUSINESS MANAGER Roger Adler
BUSINESS DEVELOPMENT MANAGER
Jeff Burak

EDITORIAL OPERATIONS
Richard K. Prue (Director), Brian Fellows (Manager),
Keith Aurelio, Charlotte Coco, John Goodman,
Kevin Hart, Norma Jones, Mert Kerimoglu, Rosalie Khan,
Patricia Koh, Marco Lau, Brian Mai, Po Fung Ng,
Lorenzo Pace, Rudi Papiri, Robert Pizaro, Barry Pribula,
Clara Renauro, Donald Schaedtler, Hia Tan,
Vaune Trachtman, David Weiner

TIME INC. HOME ENTERTAINMENT

PUBLISHER Richard Fraiman
GENERAL MANAGER Steven Sandonato
EXECUTIVE DIRECTOR, MARKETING SERVICES
Carol Pittard
DIRECTOR, RETAIL & SPECIAL SALES
Tom Mifsud
DIRECTOR, NEW PRODUCT DEVELOPMENT
Peter Harper
DIRECTOR OF TRADE MARKETING Sydney Webber
ASSISTANT DIRECTOR, BOOKAZINE MARKETING
Laura Adam
ASSISTANT DIRECTOR, BRAND MARKETING
Joy Butts
ASSOCIATE COUNSEL Helen Wan
BOOK PRODUCTION MANAGER Suzanne Janso
DESIGN & PREPRESS MANAGER
Anne-Michelle Gallero
BRAND MANAGER Shelley Rescober

SPECIAL THANKS TO
Glenn Buonocore, Susan Chodakiewicz, Lauren Hall,
Margaret Hess, Jennifer Jacobs, Brynn Joyce, Robert Marasco,
Amy Migliaccio, Brooke Reger, Mary Sarro-Waite,
Ilene Schreider, Adriana Tierno, Alex Voznesenskiy,
Jonathan White

ISBN 10: 1-60320-058-4
ISBN 13: 978-1-60320-058-5
Library of Congress Number: 2009900526

"LIFE" is a trademark of Time Inc.

We welcome your comments and suggestions about
LIFE Books. Please write to us at:
LIFE Books
Attention: Book Editors
PO Box 11016
Des Moines, IA 50336-1016

If you would like to order any of our hardcover Collector's
Edition books, please call us at 1-800-327-6388
(Monday through Friday, 7:00 a.m.–8:00 p.m.,
or Saturday, 7:00 a.m.–6:00 p.m., Central Time).

Classic images from the pages and covers of LIFE are now
available. Posters can be ordered at www.LIFEposters.com.

Fine art prints from the LIFE Picture Collection and
the LIFE Gallery of Photography can be viewed at
www.LIFEphotographs.com.

Endpaper illustration courtesy of Michael Roseman

"There's something like a line of gold thread running through a man's words when he talks to his daughter."
— John Gregory Brown, American novelist

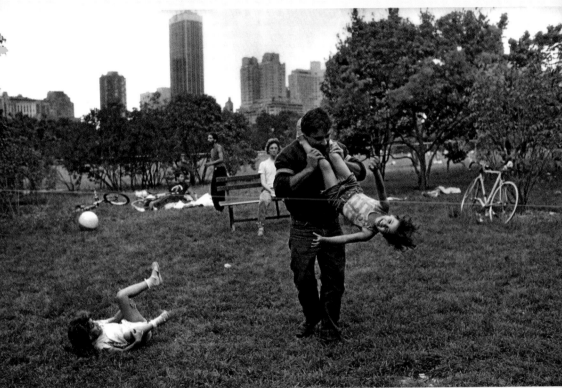

MAGNUM

HEADLOCK
New York City's Central Park serves as a handy
location for some father-daughter free-for-all.
Photograph by Ferdinando Scianna

INTRODUCTION

A FATHER'S JOB IS A UNIQUE AND OFTEN UNDERAPPRECIATED ONE. A man who has children is expected to be, in many instances, not simply a reliable breadwinner, a role model, a coach of myriad sports but also a loving and nurturing parent—an assignment ascribed until fairly recently only to Mom. As he accepts the truth and pleasure of this role, he is also expected to be a brave protector against any small or large onslaughts from the big, scary world, to be present in moments of crisis, and then, too, to be available to come up with the right answer to any question, to be firm when firmness is called for and to encourage and praise when that is what he feels his child needs. He hopes to be the apple of his daughter's eye and the man his son wants to one day become. As a man's children grow older—in the best of possible worlds, if he got some of it right—he will evolve into a counselor and then into a confidant and pal. A child who comes to trust his or her father implicitly is a fortunate child indeed.

To a childless friend it might appear that it is not always easy being Dad. Did he really want to give up the NFL game to go to the father-daughter dance? Did he willingly forgo golf with his buddies to catch the eight-and-under soccer game? Is it important for him to attend the 8 a.m. parent-teacher conference with his wife when it means he'll work late that night at the office?

As all fathers can tell you, and as the pictures in this book confirm in spades, the answers are yes, yes, yes.

And why?

Well, as you look at these moving, poignant, fun and even funny photographs, pay close attention to the faces of the children as well as those of the fathers. You see joy there certainly, and love. But over and over again: pride. What a payoff for Dad.

We venerate our mothers, and we honor our fathers. Together with Mom—or sometimes by himself, if she is not present—he holds the family together. He leads us. He points the way.

Certain things are expected of our fathers, and in some homes this creates inconsistencies and ironies. Mom is surely much more deft with a needle and thread, so why is it Dad's job to bait the hook? Mom drives a prudent 55 mph, while Dad adds 10 to any given speed limit, so why is he the driver of choice behind the wheel on the long-haul trips? Mom may know the best way to slice a turkey, thanks to Cooks.com, but still we turn to Dad on Thanksgiving Day. It's all part of the amusing and comfortable rhythms—the interior rules, the assumed roles—within the family.

In later years, we look back on the role-playing and smile in appreciation and, yes, admiration. It may well be that a father is most fully valued only in hindsight. From the vantage of adulthood, all the rules and regulations, the pep talks and admonishments, suddenly make sense. The sacrifices of our fathers snap into sharp focus, and they are revealed as wiser men than we ever credited them to be. Ask any dad and he'll tell you, in a contemporary paraphrase of a famous observation usually attributed to Mark Twain, "My daughter thought I was a genius, then one day I was an idiot, and now, a few years later, I'm a genius again."

In this book, Dad's genius shines.

We first published LIFE with Father several years ago, and we returned to that volume when planning our new edition. We have retained some classic images, including those of a few very famous fathers, and we have added many, many new ones, plus words of paternal wisdom from fine thinkers past and present. It has been nothing short of a joy to return to the inspiring subject of fatherhood. We hope you will agree when you turn these pages.

With much affection, then: our tribute to fathers everywhere. Here's to you, Dad!

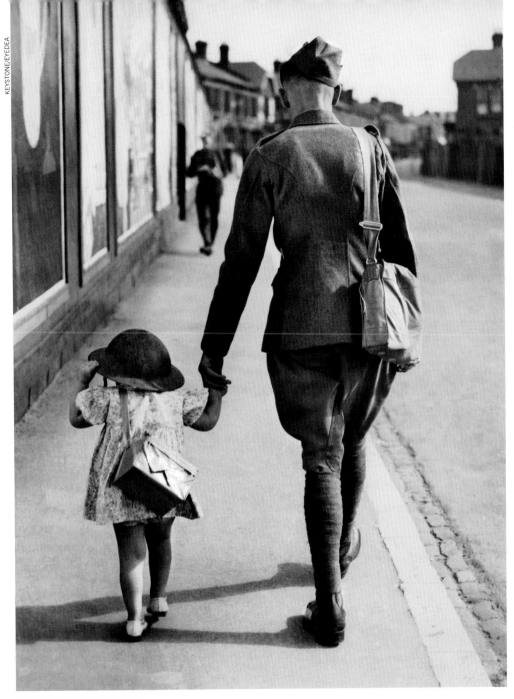

MARCHING ORDERS
A soldier takes a stroll with his daughter, who is wearing the latest in hats.

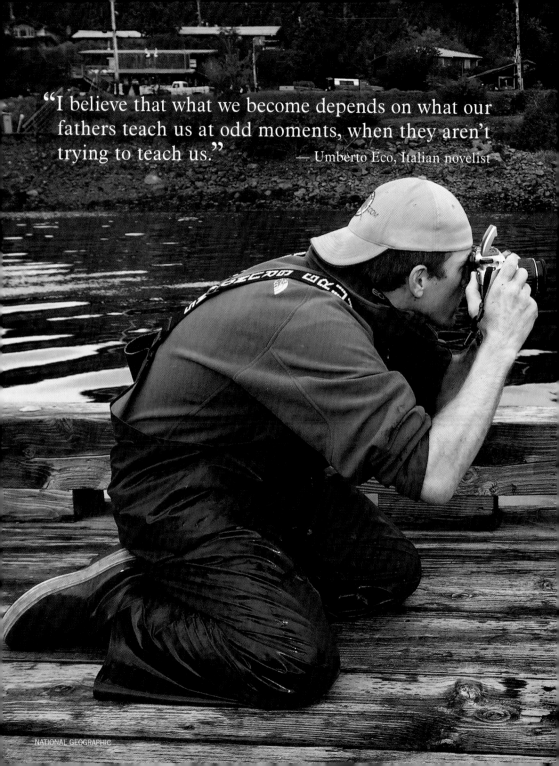

"I believe that what we become depends on what our fathers teach us at odd moments, when they aren't trying to teach us."

— Umberto Eco, Italian novelist

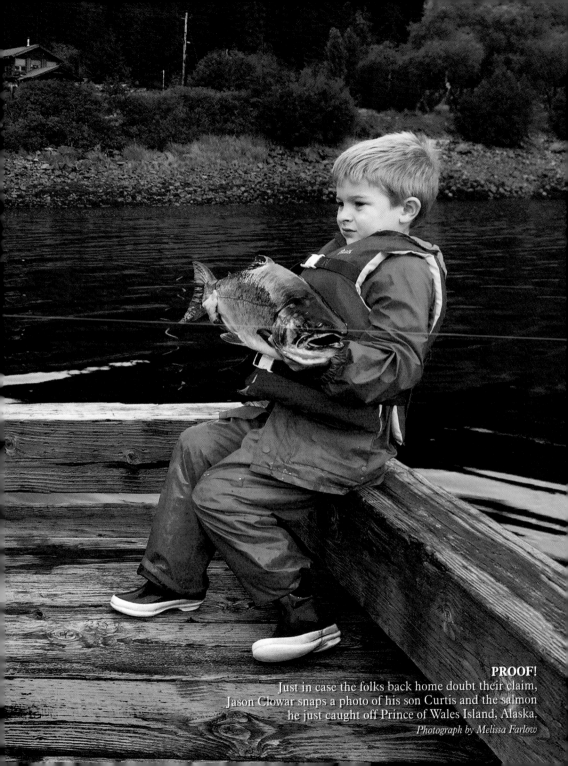

PROOF!
Just in case the folks back home doubt their claim,
Jason Clowar snaps a photo of his son Curtis and the salmon
he just caught off Prince of Wales Island, Alaska.
Photograph by Melissa Farlow

"One night a father overheard his son pray: 'Dear God, make me the kind of man my daddy is' . . .

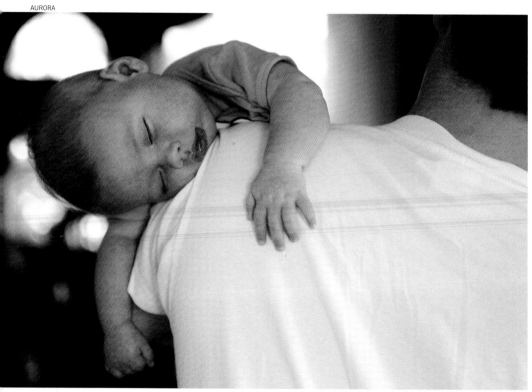

ZZZZZZZ
A two-month-old boy takes a catnap on
his father's shoulder in Marblehead, Massachusetts.
Photograph by Laurie Swope

... Later that night, the father prayed, 'Dear God, make me the kind of man my son wants me to be.'"

— Anonymous

PLEASE, DON'T EAT THE STARFISH
The tidal pools of Harris Beach State Park in Oregon make a great place for a father and his children to explore the wonders of life together.
Photograph by Paul Zahl

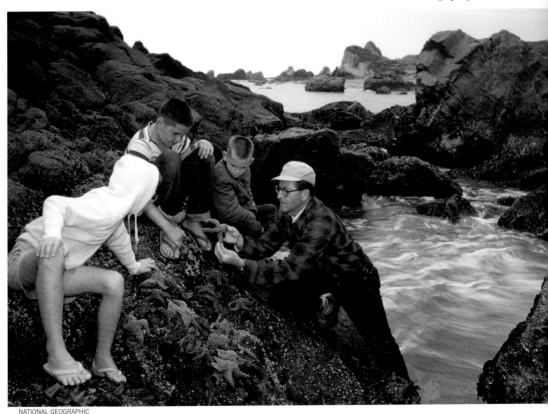

"The love of a father is one of nature's greatest masterpieces.**"**

— Anonymous

BLOW, GABRIEL, BLOW

Nine-year-old Yu Xi can't play his trumpet at home because the noise bothers the neighbors, so his father, Yu He, takes him to a Beijing park every day and helps him practice.

Photograph by Stuart Franklin

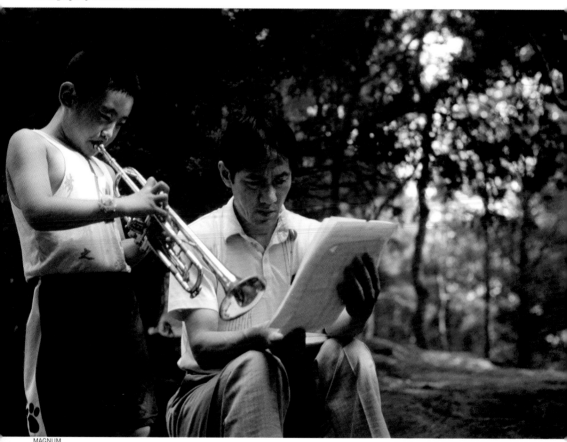

MAGNUM

ALPINE IDYLL

On a dairy farm in Appenzell, Switzerland, a dad puffs on his pipe while his son gets in a hug.

Photograph by Cotton Coulson

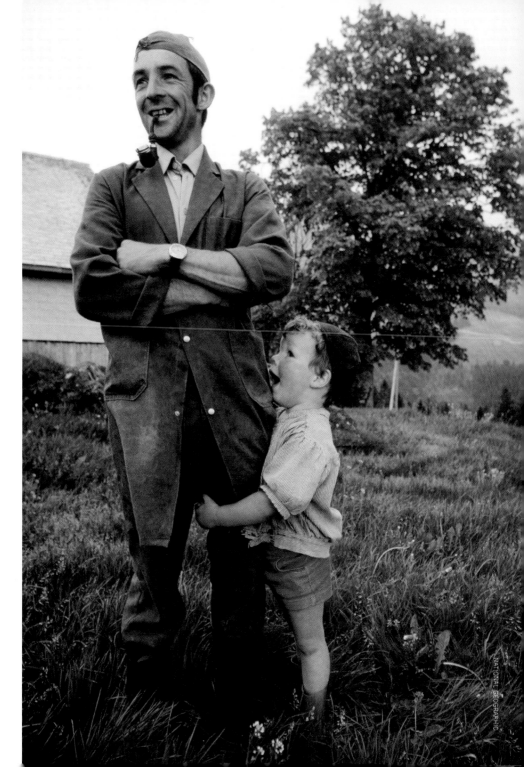

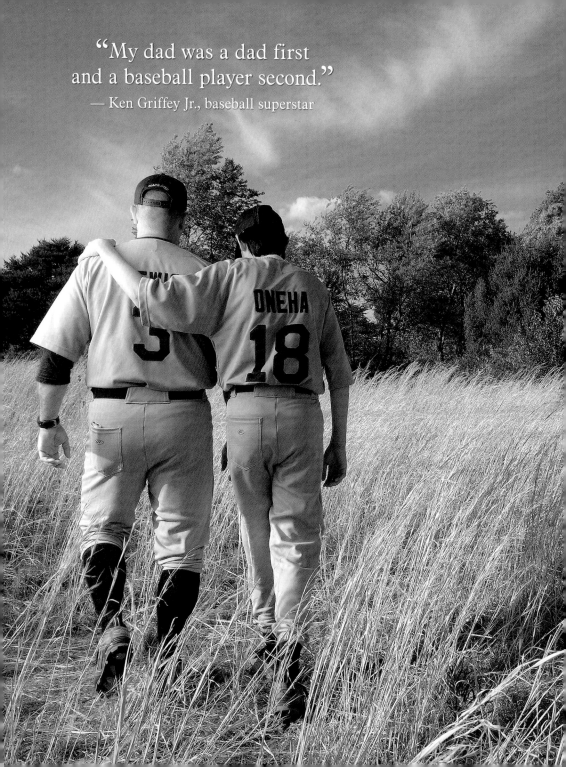

"My dad was a dad first
and a baseball player second."
— Ken Griffey Jr., baseball superstar

LIKE FATHER, LIKE SON
Volunteer coach Navy Petty Officer
Michael Lewis and his adopted son
Anthony Oneha walk in the tall grass
before a game at the Fort George G. Meade
baseball fields in Maryland.
Photograph by Tom Sperduto

> "The family you come from isn't as important as the family you're going to have."
> — Ring Lardner, American writer

WALTZING AROUND
Suzanne Teets enjoys the company of her father, businessman John Teets, at New York City's International Debutante Ball.
Photograph by Michael Melford

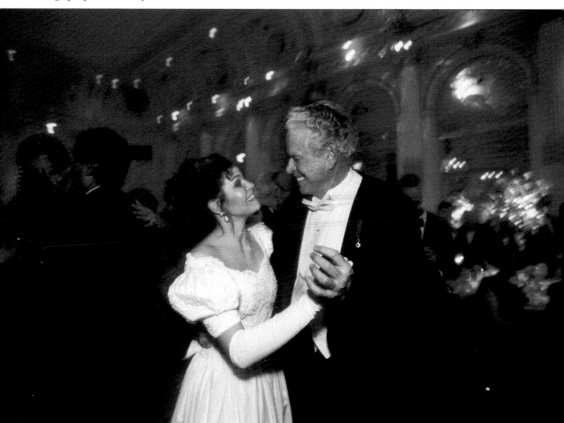

SERIOUS BUSINESS
A dad takes advantage of a break in the competition to squire his daughter across the floor during a children's dancing championship at London's Royal Albert Hall.
Photograph by David Hurn

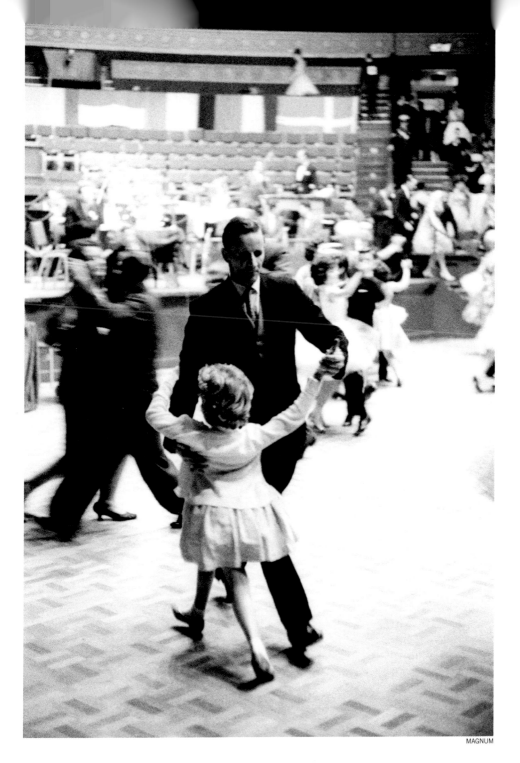

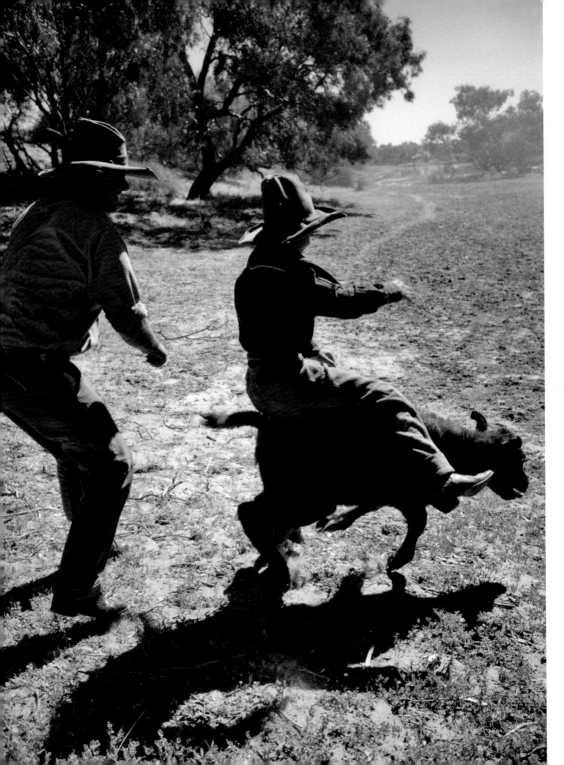

"When you teach your son, you teach your son's son."

— The Talmud

RAKING IT IN
In Atlanta, Paul Sartore gives his
three-year-old son an early lesson in yard work.
Photograph by Joel Sartore

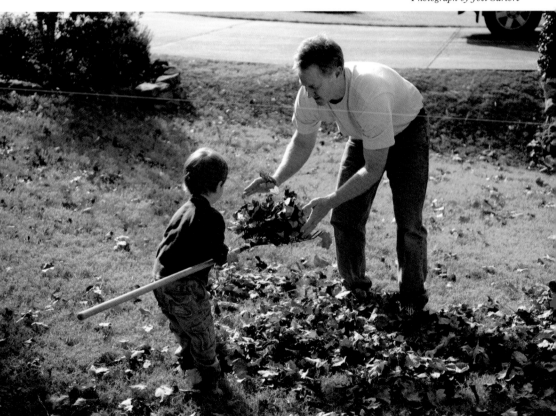

RIDE 'EM, COWBOY
It may look like a scene from the Old West, but these buckaroos
are actually a father and son living in Clifton Hills, South Australia.
Photograph by Robert B. Goodman

"Blessed indeed is the man who hears many gentle voices call him father!"
— Lydia Maria Child, American abolitionist

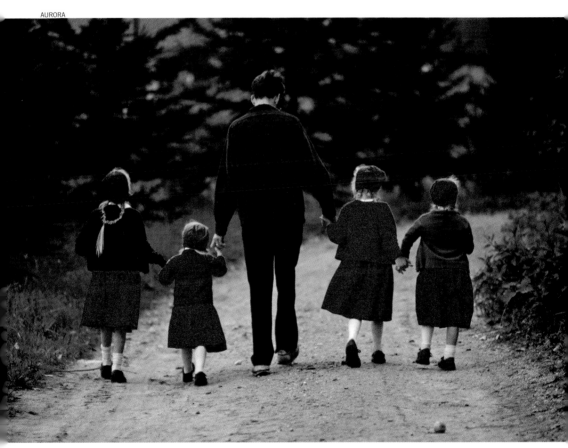

MY FOUR DAUGHTERS
A Hutterite father takes his girls for a walk in the Connecticut countryside.
Photograph by Robb Kendrick

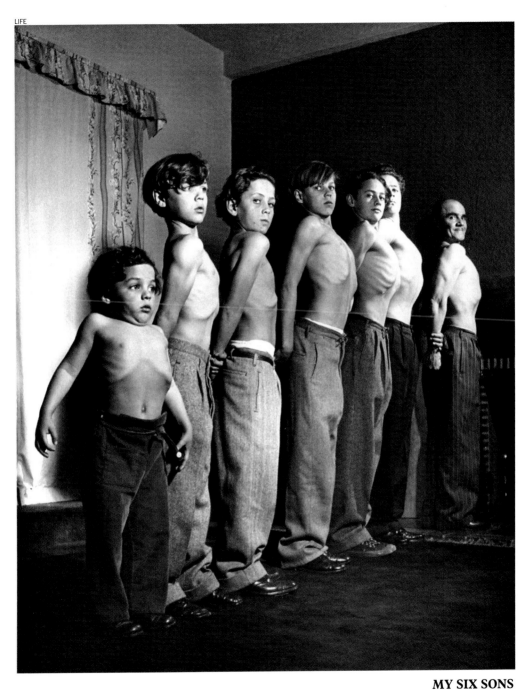

MY SIX SONS
Actor Clifford Brill Severn poses shirtless with his he-men offspring.
Photograph by Peter Stackpole

> **"**To a father growing old
> nothing is dearer than
> a daughter.**"**
> — Euripides, Greek playwright

AURORA

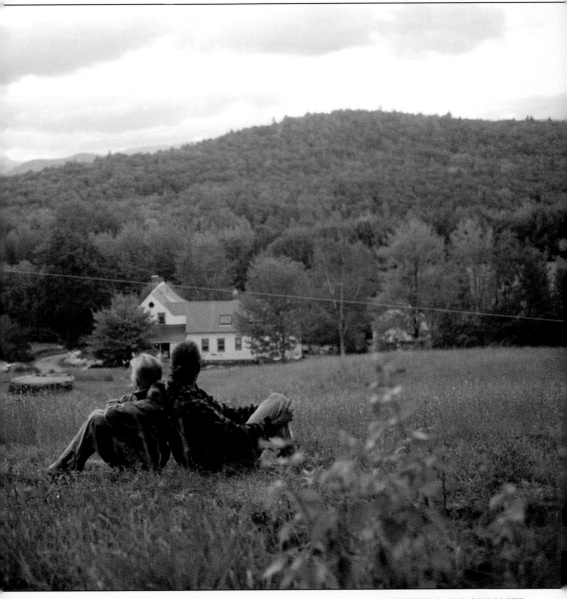

FAREWELL TO SUMMER
A fallow field is the setting as a father and daughter gaze at the
hills of Lovell, Maine, which are just showing the first colors of fall.
Photograph by Andrew Lichtenstein

"It doesn't matter who my father was;
it matters who I remember he was."

— Anne Sexton, American poet

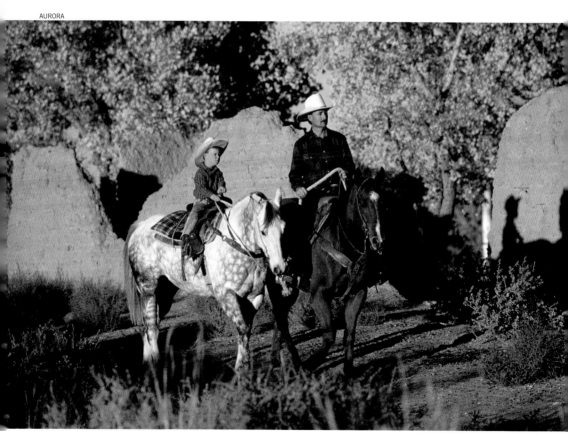

BACK IN THE SADDLE
Bunk Mullins and his four-year-old son, Byron, hit the trail together
at the remains of Fort Seldon in Radium Springs, New Mexico.
Photograph by Cary Wolinsky

WEDDING DAY JITTERS
In Taiwan, Kun-Hsun Chen's father prepares to say goodbye to his tearful daughter.
Photograph by Chien-Chi Chang

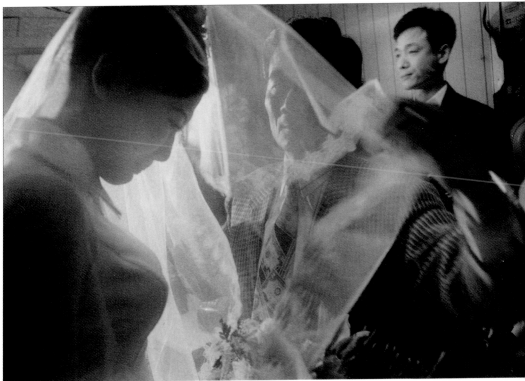

> **"If your parents never had children, chances are you won't either."**
> — Dick Cavett, American television talk show host

BALANCING ACT
In Virginia Beach, Virginia, a father of twins knows no rest.
Photograph by Karen Kasmauski

"Grown men can learn from very little children for the hearts of little children are pure . . .

FAITH OF THE FATHERS
A young boy in Khartoum, Sudan, is gently
led toward the mysteries of his parents' religion.
Photograph by Marco Di Lauro

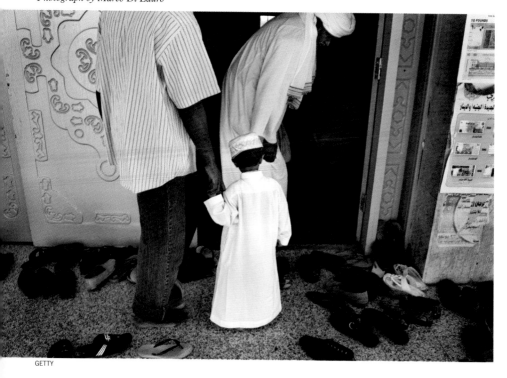

> . . . Therefore, the Great Spirit may show to them
> many things which older people miss."
> — Black Elk, Oglala Lakota Sioux holy man

SERENITY
Photographer Robert Frank takes a little time off in New York City
to catch up on his rest and contemplate his tiny son, Pablo.
Photograph by Elliott Erwitt

NEVER LETTING GO

Thomas Coffey tightly hugs his father,
Major Rod Coffey of the Third Infantry Division, who
is home for a visit in between tours of duty in Iraq.

Photographs by Richard Perry

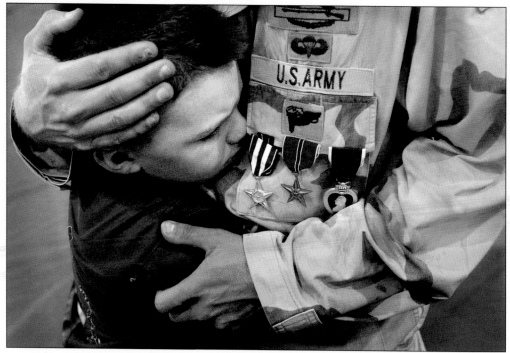

"If we are to teach real peace in this world, and if we are to carry on a real war against war, we shall have to begin with the children."

— Mahatma Mohandas Gandhi, Indian political and spiritual leader

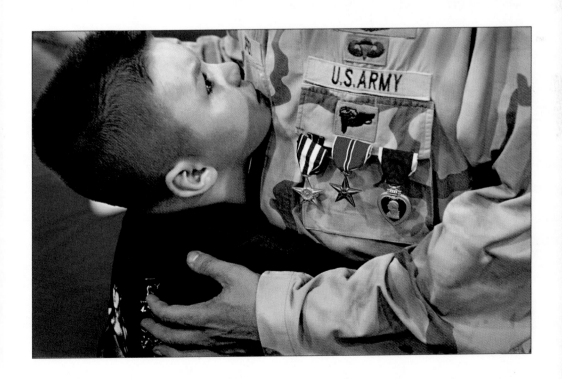

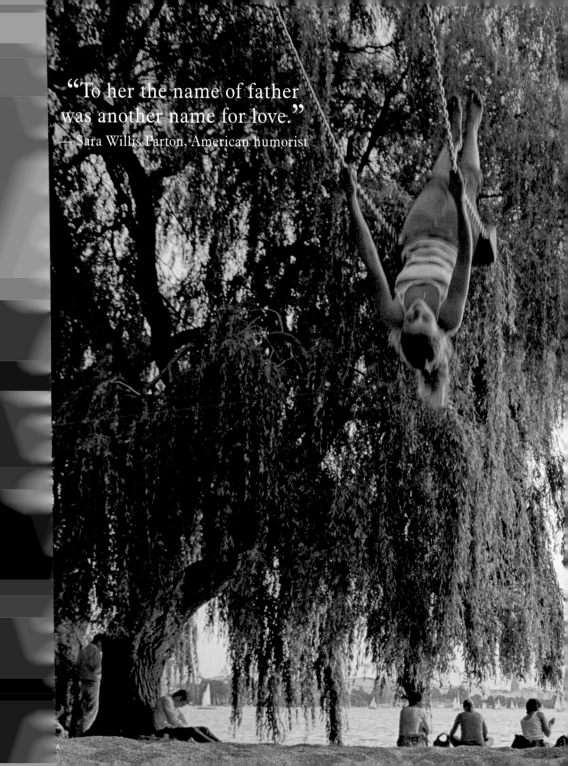

"To her the name of father was another name for love."
— Sara Willis Parton, American humorist

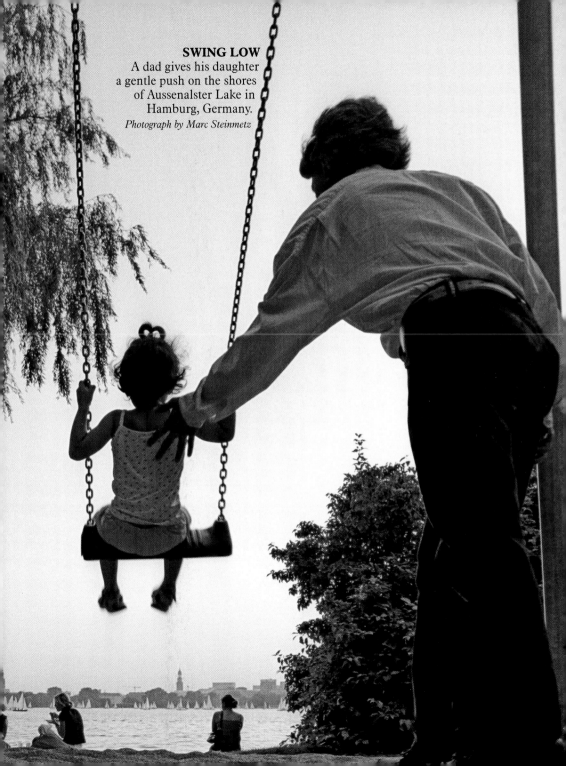

SWING LOW
A dad gives his daughter
a gentle push on the shores
of Aussenalster Lake in
Hamburg, Germany.
Photograph by Marc Steinmetz

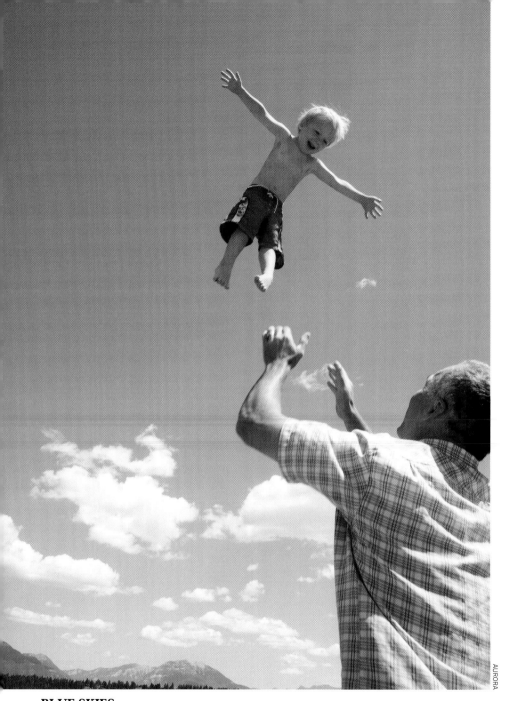

AURORA

BLUE SKIES
A father introduces his son to weightlessness near Fernie, British Columbia.
Photograph by Henry Georgi

"When a child is born, a father is born."
— Carl Frederick Buechner, American minister and author

SMILES AND SPLASHES
A brother and sister share some precious time with their father in the water off Foncillon Beach in Royan, France.
Photograph by Jean Gaumy

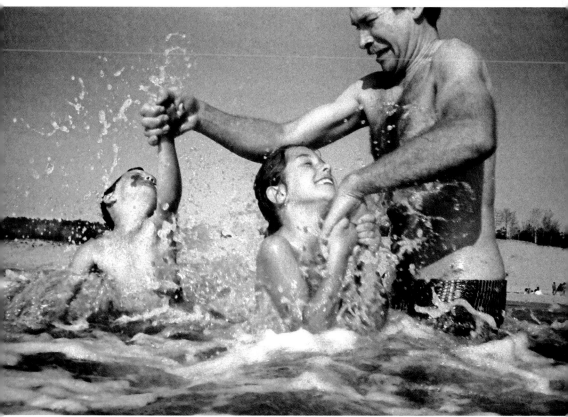

"Sometimes the poorest man leaves his children

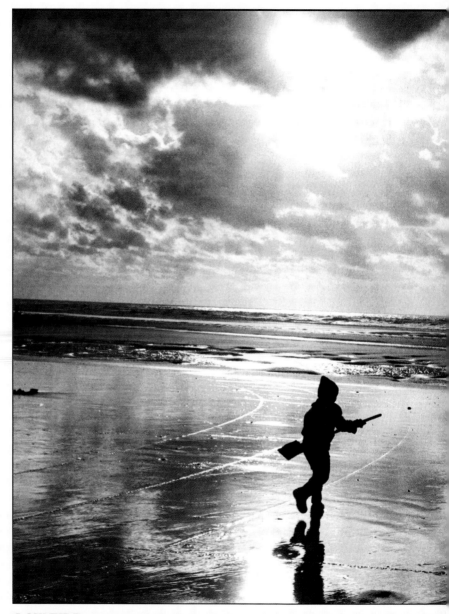

LOW TIDE
Father and son go clamming together on the coast of Pas-de-Calais in France.
Photograph by Henri Cartier-Bresson

the richest inheritance." — Ruth E. Renkel, American writer

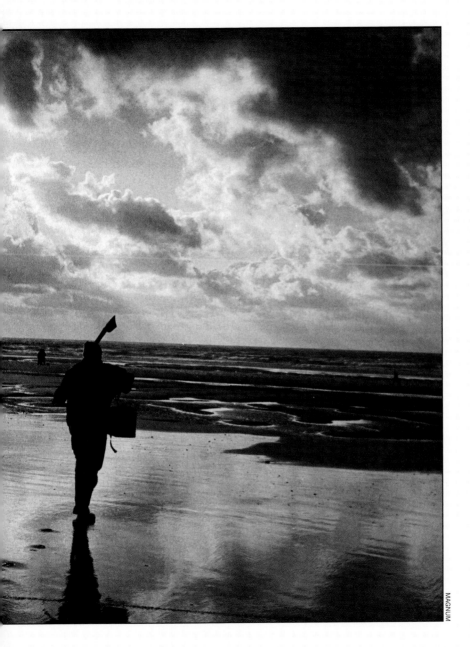

MAGNUM

KEEP ON TRUCKIN'

With broad smiles an African farmer and his daughter maintain
a slow but steady pace on their way to Lalibela, Ethiopia.

Photograph by Raymond Depardon

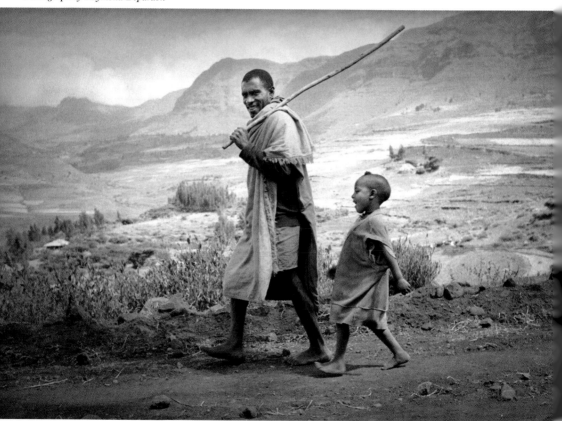

> "When you follow in the path of your father, you learn to walk like him."
>
> — Proverb of the Ashanti tribe in Africa

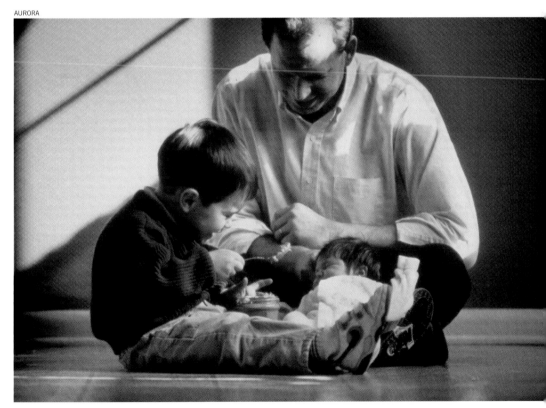

PEANUT BUTTER SPECIAL
Big brother Eric tries to offer his baby sister, Lauren Murphy Evans,
a special treat on her first day in their Westminster, Maryland, home,
while their father, Ray, keeps a close eye on things.

Photograph by Lynn Johnson

Even a famous father
is simply Dad to his kids

"I just want the pine trees and my kids and the green grass. I want to get rich and fat and watch my children grow." — Steve McQueen, American actor

HE'S NO PUSHOVER
Three-year-old Chad McQueen
head-butts his father in their Hollywood home.
Photograph by John Dominis

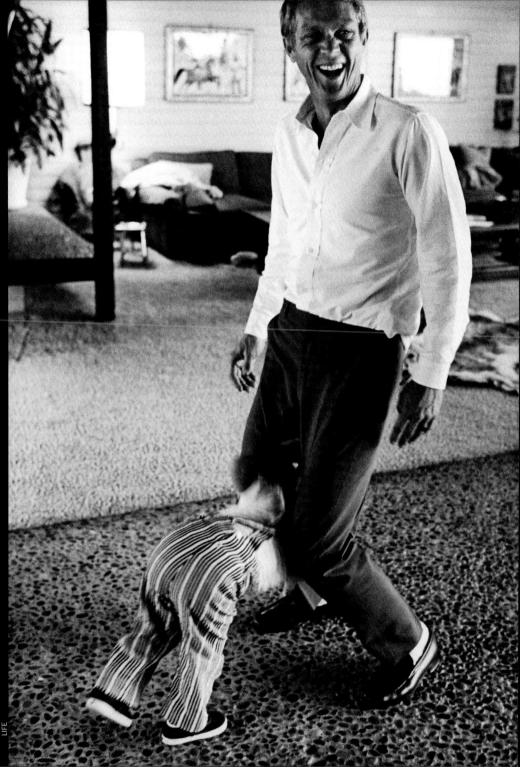

"My mother gave me my drive, but my father gave me my dreams."
— Liza Minnelli, American Actress

BEAUTIFUL DREAMERS
Director Vincente Minnelli and his daughter Liza
see eye to eye in Palm Springs, California.
Photograph by Douglas Kirkland

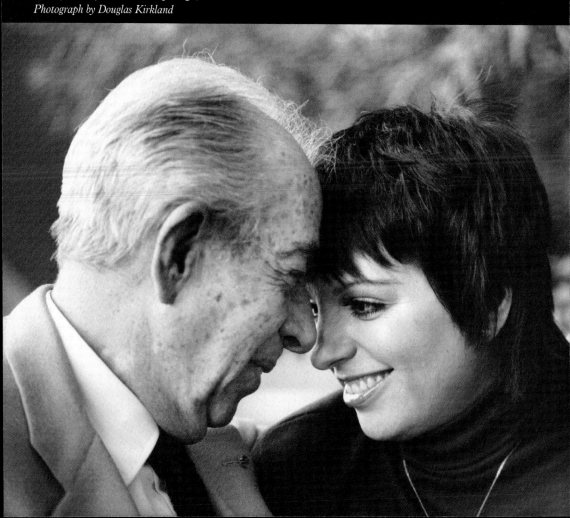

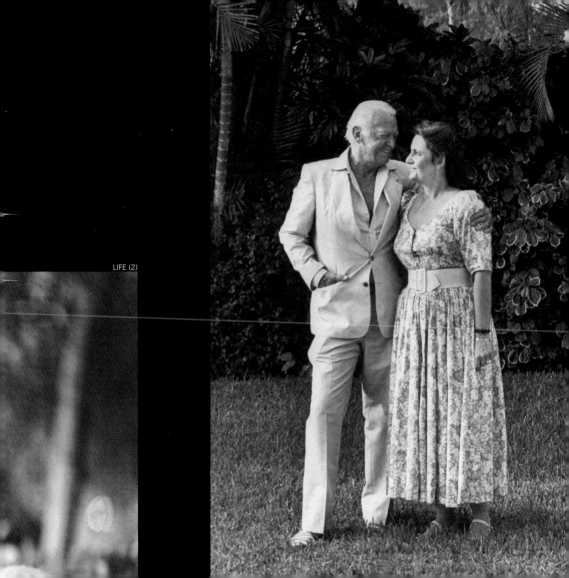

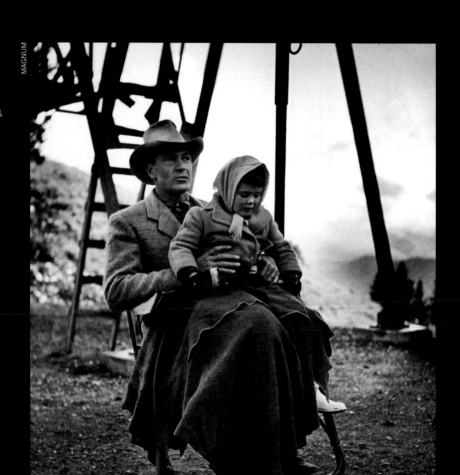

"My girlhood was spent with one foot in Oz and one foot in the real world."

— Maria Cooper Janis, daughter of actor Gary Cooper

GOTCHA!
. . . And a few years later, her snowball catches Dad
by surprise during a ski vacation in Aspen, Colorado.
Photograph by Peter Stackpole

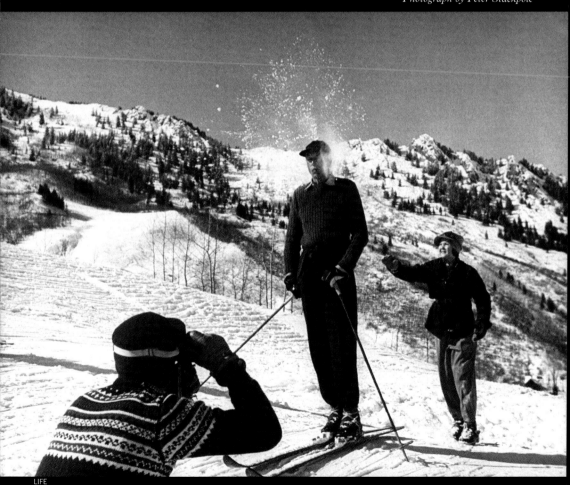

> "Being a father is the best thing that ever happened to me in my life. It kind of makes any success I have on the stage or screen very unimportant by comparison."
>
> — Fred Astaire, American dancer and actor

IT RUNS IN THE FAMILY
Fred teachs his son, Fred Jr., the finer points of hoofing it in the living room of their Hollywood home.

Photograph by Bob Landry

LIFE (2)

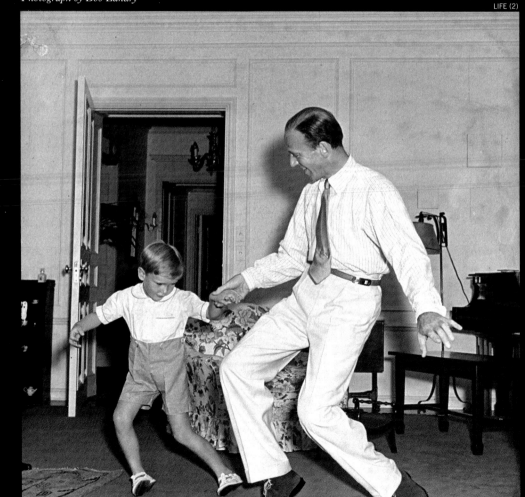

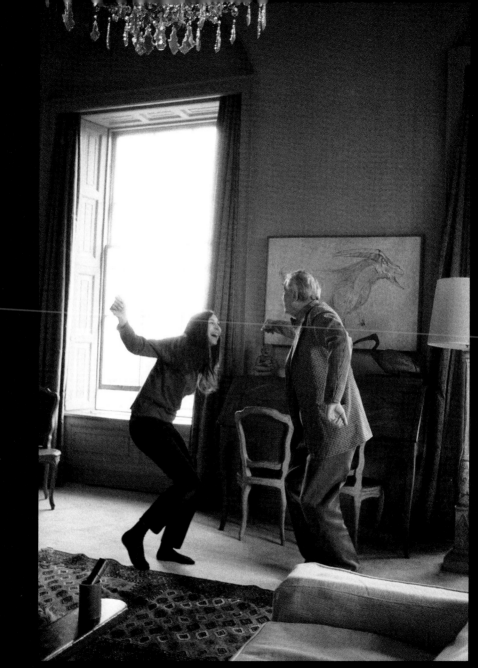

DANCING UP A STORM
Film director and actor John Huston gives his daughter and
actress-to-be, Anjelica, some stiff competition as they cut a rug
at St. Cleran's, Dad's home in County Galway, Ireland.

Photograph by Loomis Dean

"Where are you goin', my little one, little one?
Where are you goin', my baby my own?
Turn around and you're two
Turn around and you're four . . .

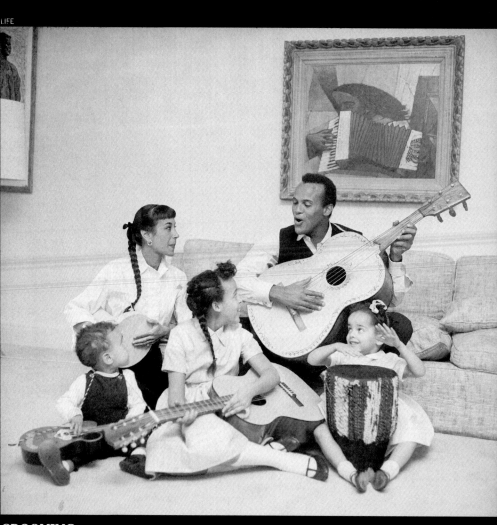

CROONING
Harry Belafonte sits down for a sing-along with his wife, Julie,
his son, David, and daughters Adrienne and Shari.

. . . Turn around and you're a young girl
Going out of the door."
— Harry Belafonte, American musician,
actor and social activist

JAMMING
Legendary musician Hank Williams poses with son, future country
music star Hank Williams Jr., whom he nicknamed "Bocephus."

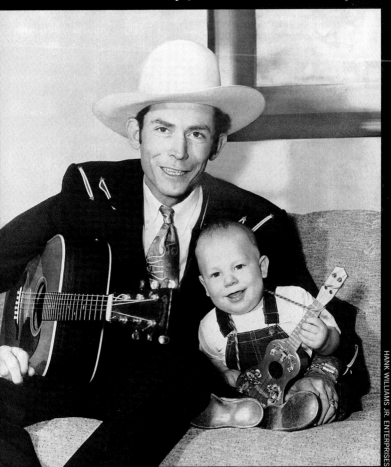

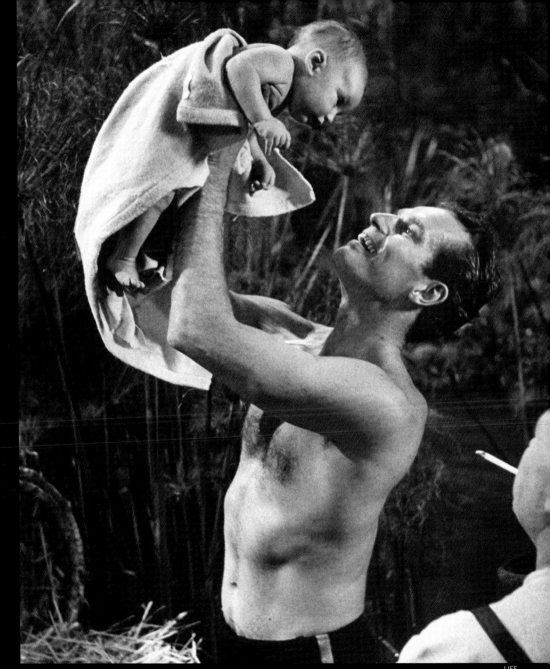

LIFE

TWO PROPHETS
The infant Fraser and his father, Charlton Heston, go over their lines during a break from shooting *The Ten Commandments,* in which Fraser plays Moses as a baby while Dad tackles the adult role.
Photograph by George Silk

**"Was I
a good father?"**
— Kirk Douglas, American actor

**"You have ultimately been
a great father."**
— Michael Douglas, American actor

PUMPING IRON
Joel (left) and Michael Douglas help their father get a workout.

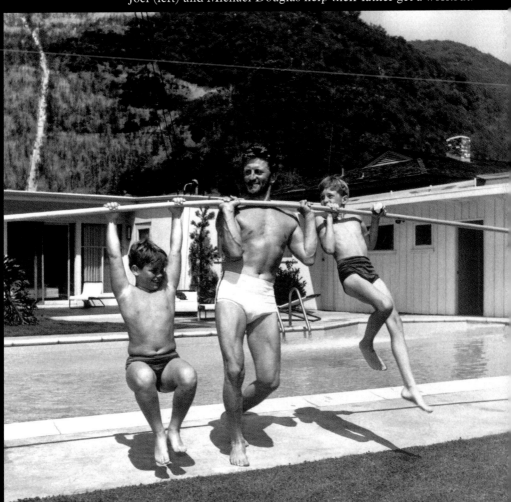

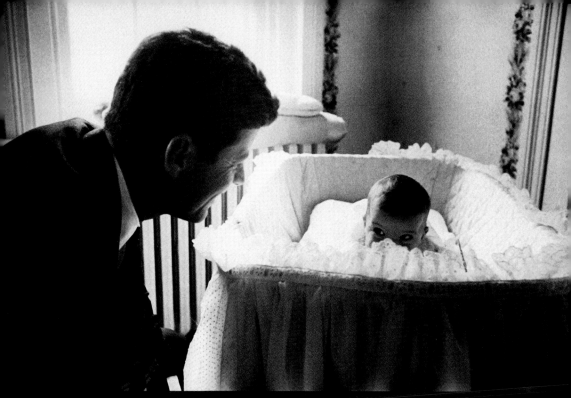

PEEKABOO?
Senator and future President John Fitzgerald Kennedy
smiles at his infant daughter, Caroline.
Photograph by Ed Clark

GOODNIGHT, SLEEP TIGHT
A young Joe Kennedy giggles and squirms as
his father, Robert, tries to deliver a bedtime kiss.
Photograph by Paul Schutzer

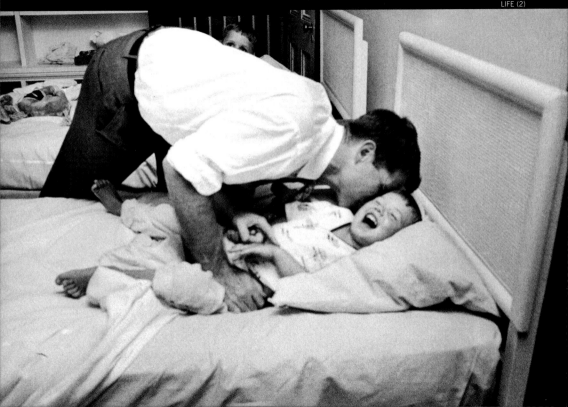

> **"I** felt something impossible
> for me to explain in words . . .
> Then it came to me . . . I was a father.**"**
> — Nat "King" Cole, American musician

LIKE FATHER, LIKE DAUGHTER
Seven-year-old Sweetie, better known today as the singer Natalie Cole, receives an early voice lesson from her famous father.

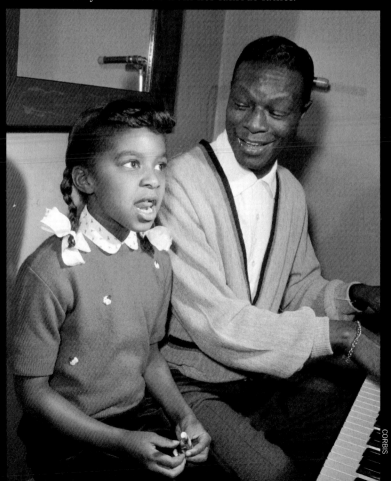

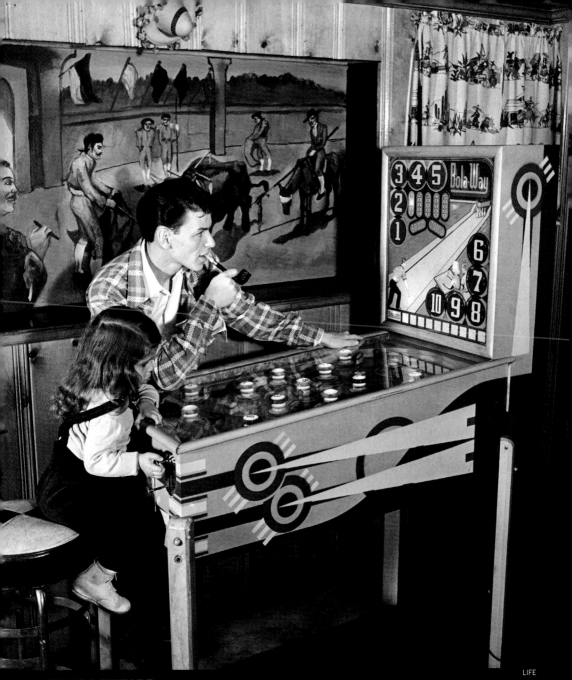

PINBALL WIZARD
Daughter Nancy Sinatra shows off her skills to her father, Frank,
in their Hasbrouck Heights, New Jersey, home.
Photograph by Herbert Gehr

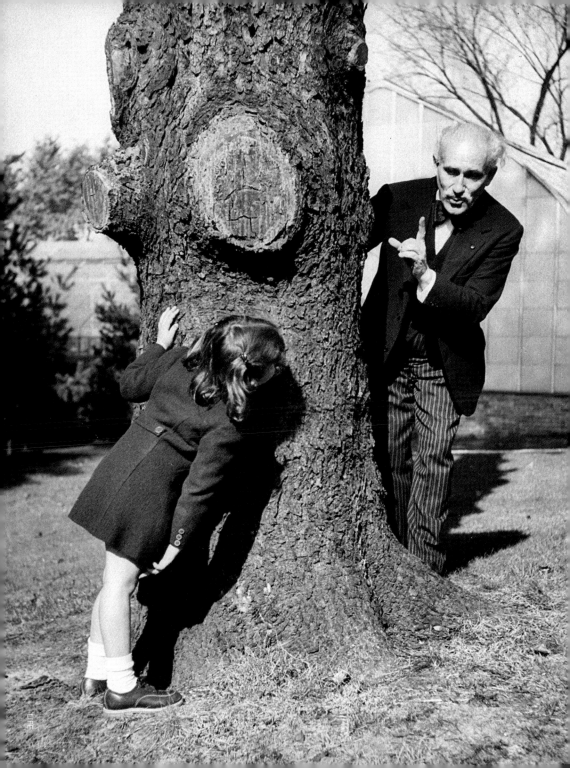

"Which would you rather be, a conductor or a pianist?"
— Arturo Toscanini, Italian conductor

"A conductor. It's easier."
— Sonia Toscanini Horowitz, Toscanini's granddaughter

OLLY OLLY OXEN FREE
Renowned conductor Toscanini lets his hair down to
frolic with his granddaughter Sonia in the Riverdale, New York,
yard of her equally famous father, pianist Vladimir Horowitz.
Photograph by Herbert Gehr

> **"**Certain is it that there is no kind of affection
> so purely angelic as of a father to a daughter.**"**
>
> — Joseph Addison, English essayist

BLITHE SPIRITS
Evan Egana happily—and finally—dances with her father,
Ronald, at the Young Men Illinois Club Carnival Ball, 18 months after
Hurricane Katrina devastated New Orleans, forcing postponement of the event.
Photograph by Katja Heinemann

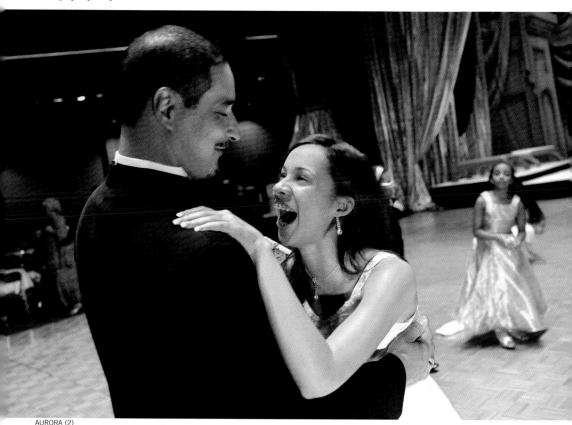

AURORA (2)

GOOD TIMES
A private joke has brought a smile to this father and daughter
resting on a wall on the Michael Ferriter farm in County Kerry, Ireland.
Photograph by Joanna B. Pinneo

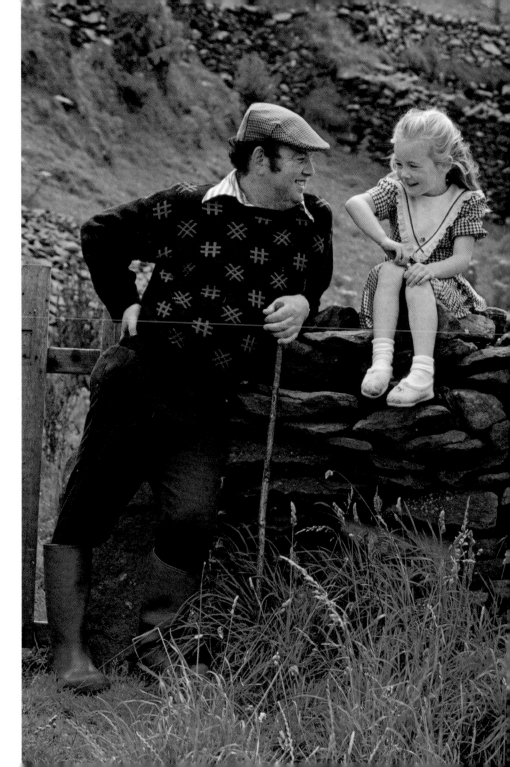

> "A father is a man who expects his children to be as good as he meant to be."
>
> — Carolyn Coats, American writer

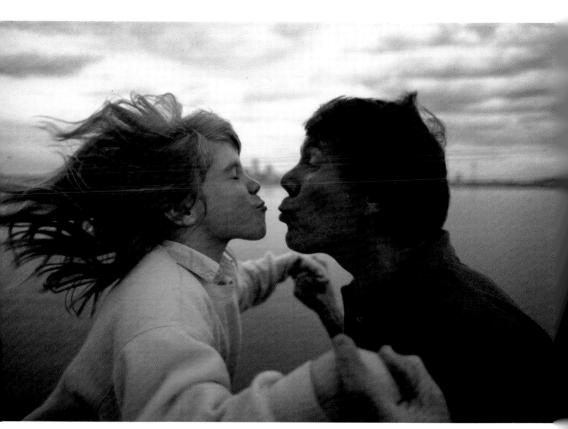

ON THE WATERFRONT
Katie Davis closes her eyes just before getting
a peck from her father, Bruce, by Seattle's Puget Sound.
Photograph by Eddie Adams

SUDSY
While Max and Felix look on, their newborn brother, Theo, gets his first bath in Leeds, England.
Photograph by Peter Marlow

> "My father was always there for me when I lost. But, then, I never really lost when my father was there."
>
> — Laurie Beth Jones, American motivational speaker

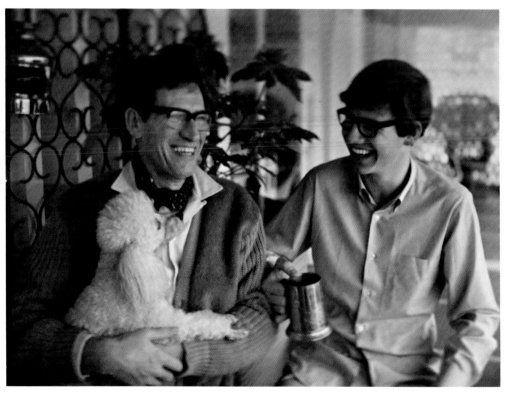

THE DOG DOESN'T GET IT
Photojournalist Larry Burrows shares a laugh with his son, Russell, at his Hong Kong home.

Photograph courtesy of the Burrrows family

ANCHORS AWEIGH, MY GIRL
Admiral William J. Fallon congratulates his daughter Christina on her
graduation from the United States Naval Academy in Annapolis, Maryland.
Photograph by Annie Griffiths Belt

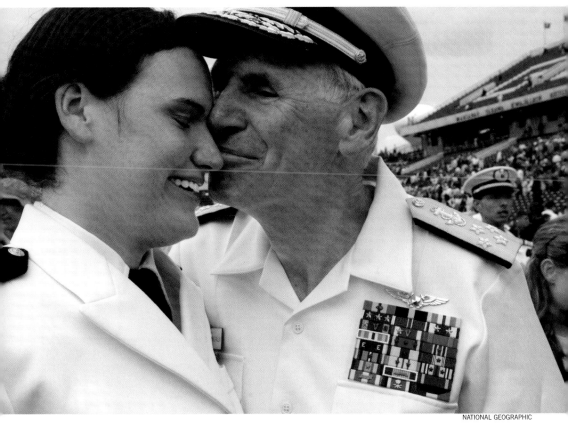

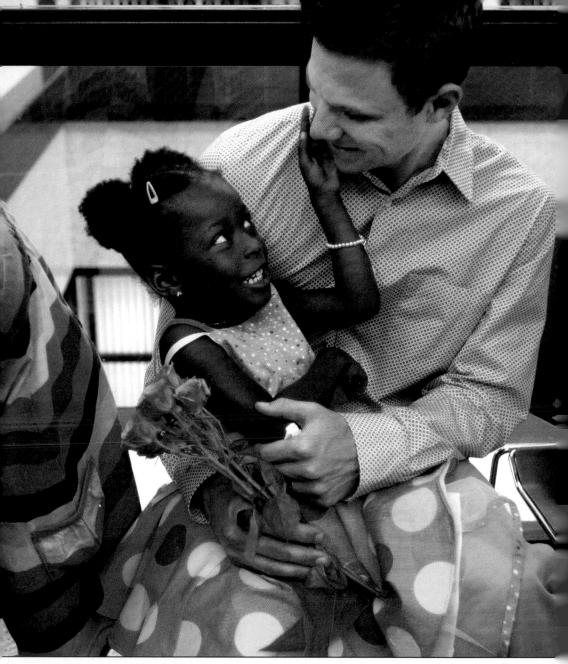

A GENTLE TOUCH BEFORE . . .
Joshua Kolkana and his daughter-to-be, Nika, share a special moment
just before her adoption ceremony in West Palm Beach, Florida.

Photographs by Uma Sanghvi

"He who brings up, not he who begets, is the father."

— Exodus Rabbah 46:5

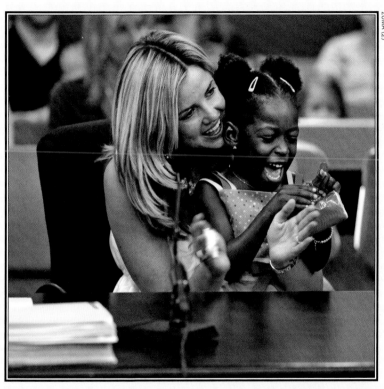

ZUMA (2)

. . . AND HAPPINESS AFTER
Nika and her mother, Kami Kolkana,
are all smiles as soon as the adoption is official.

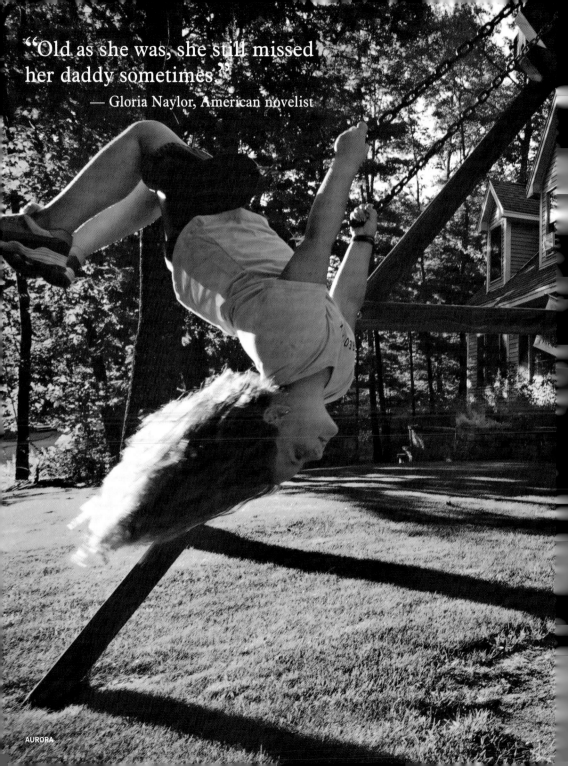

"Old as she was, she still missed her daddy sometimes."
— Gloria Naylor, American novelist

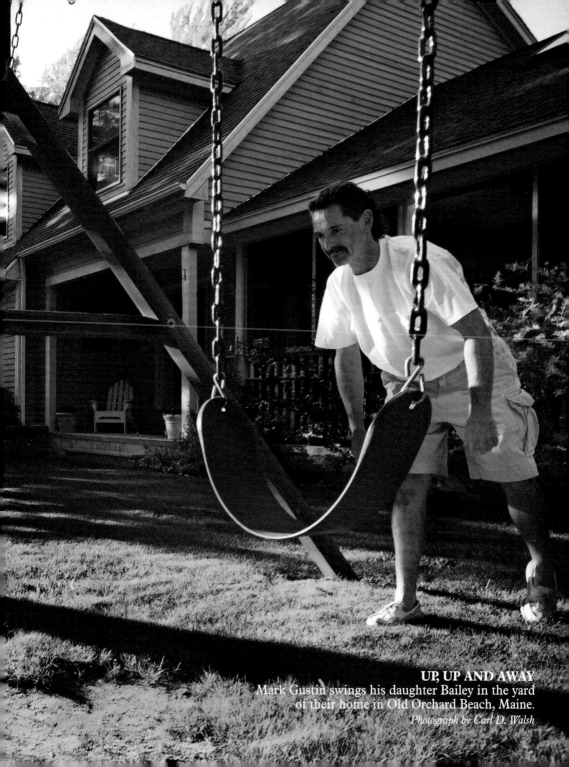

UP, UP AND AWAY
Mark Gustin swings his daughter Bailey in the yard
of their home in Old Orchard Beach, Maine.
Photograph by Carl D. Walsh

> "My heart is happy, my mind is free,
> I had a father who talked with me."
> — Hilda Bigelow, American schoolteacher

A HELPING HAND
Crossing the icy Fawn Creek in Yellowstone National Park
is no obstacle for this young hiker and her father.
Photograph by Sam Abell

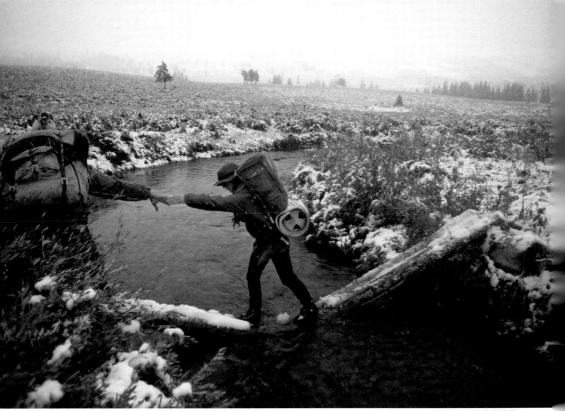

HUSBANDRY
A farmer and his son give iron supplements to some
very young piglets on their farm in Prairie Township, Iowa.
Photograph by James A. Sugar

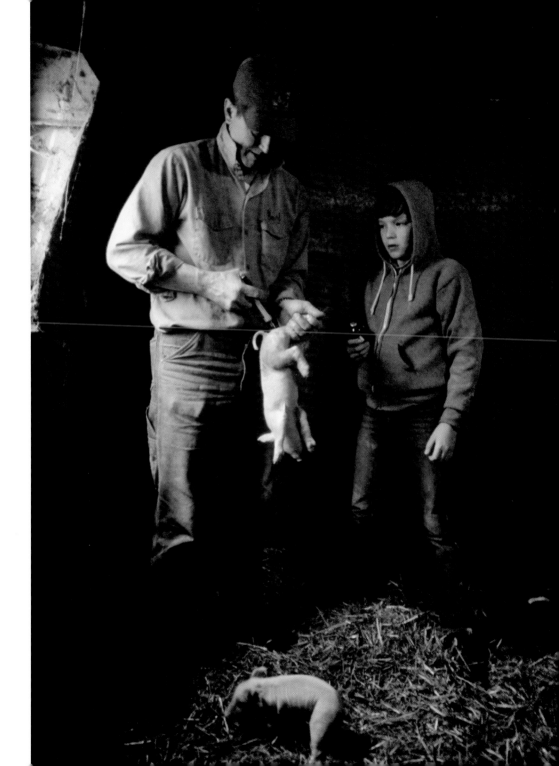

"It is a wise child that knows his own father."

— Homer, Greek poet

ONLY THE LONELY
On Alaska's North Slope, three Inuit boys
wait on an ice floe while their fathers compete
in the July 4 seal skin boat race.
Photograph by Joel Sartore

> "Before I got married I had six theories about bringing up children; now I have six children and no theories."
>
> — John Wilmot, English satirist

RUSH HOUR
Dad can barely get a chance at the sink as the whole brood crowds into the bathroom at once.

Photograph by Carl Iwasaki

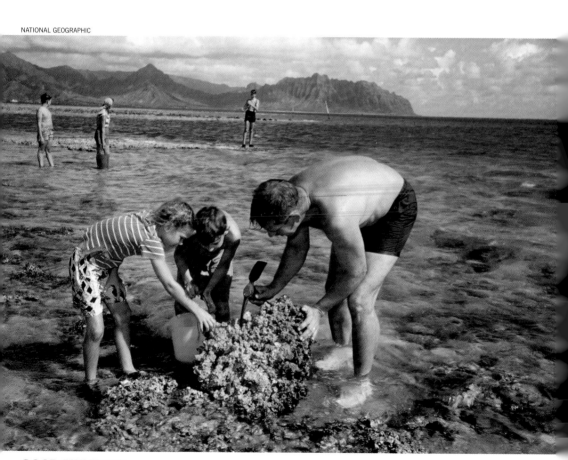

GOOD HUNTING
Kaneohe Bay on the island of Oahu in Hawaii is a perfect place for this zoologist father and his children to search for sea slugs hiding in the coral.

Photograph by Paul Zahl

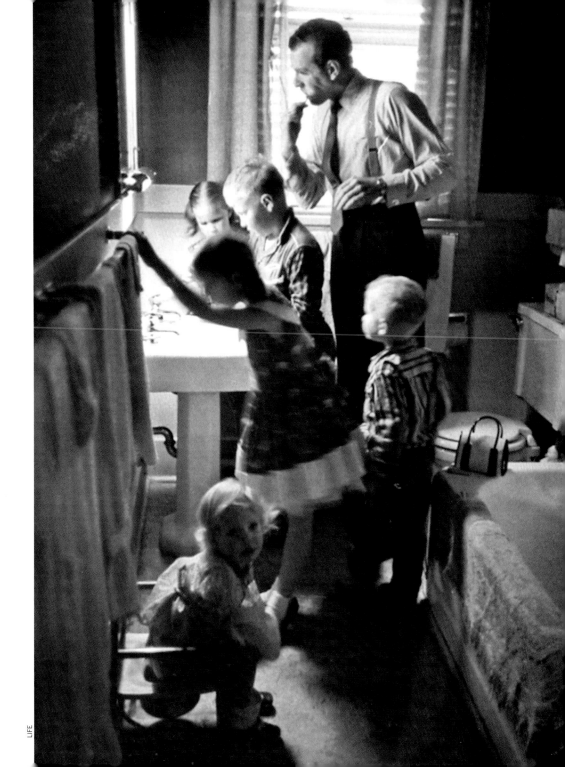

"It is not flesh and blood but the heart which makes us fathers and sons."

— Johann Schiller, German dramatist

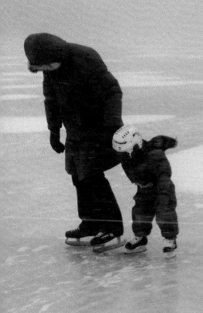

BRAVING THE ELEMENTS
Even a strong gale can't deter this father and son from
their skating outing on the Richelieu River in Quebec.
Photograph by Mark Tomalty

"Father, dear father, come home with me now,
The clock in the belfry strikes one;
You said you were coming right home from the shop,
As soon as your day's work was done."

— Henry Clay Work, American composer and songwriter

YOU SHOULD HAVE SEEN THE ONE THAT GOT AWAY
In Fox Bay Village on the Falkland Islands, a father proudly
shows off the trout he caught to his two-year-old son.
Photograph by Steve Raymer

LIFE IN BALANCE
In London's Greenwich Park, a father and
daughter while away a summer's afternoon.
Photograph by Peter Marlow

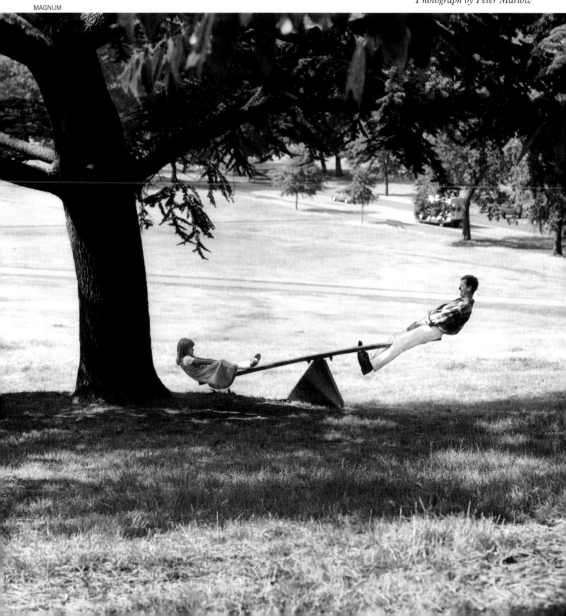

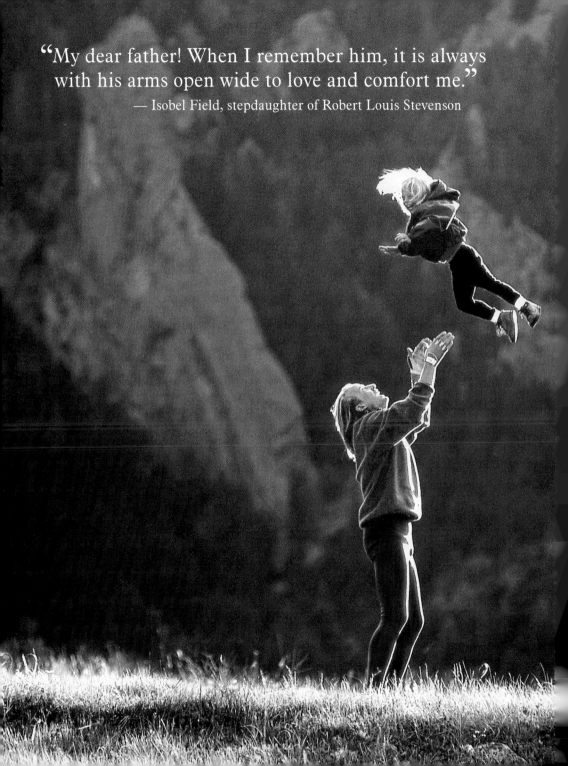

"My dear father! When I remember him, it is always with his arms open wide to love and comfort me."
— Isobel Field, stepdaughter of Robert Louis Stevenson

HOW HIGH CAN SHE GO?
As if a bike ride in the mountains
of Colorado wasn't exhilarating enough!
Photograph by Kate Thompson

RELAXING
A Portland, Maine, dad enjoys some quiet time with his infant.
Photograph by David McLain

> "A girl's father is the first man in her life, and probably the most influential."
> — David Jeremiah, American evangelist

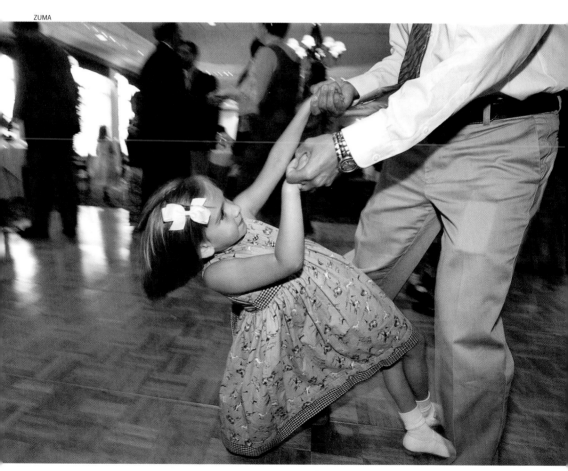

TRIPPING THE LIGHT FANTASTIC
In Delray Beach, Florida, five-year-old Celina spins around the dance floor with her father, Rudy Carrillo.

Photograph by Chris Matula

> "Fathering is the most masculine
> thing a man can do."
> — Frank Pittman, American psychiatrist

PRIDE AND JOY

Kris Koeberer shows his delight in his son Cole by
presenting him to the California sun—and the world

Photograph by Ron Koeberer

TWO COOL CATS

In his loft in New York City's SoHo district, artist Aaron Roseman
gets reacquainted with his twentysomething son, Michael.

Photograph courtesy of Roseman family

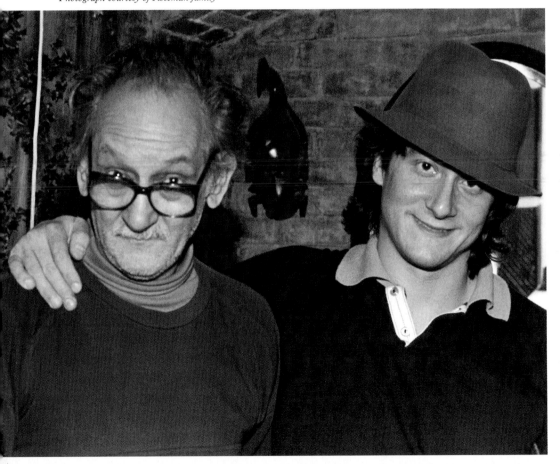

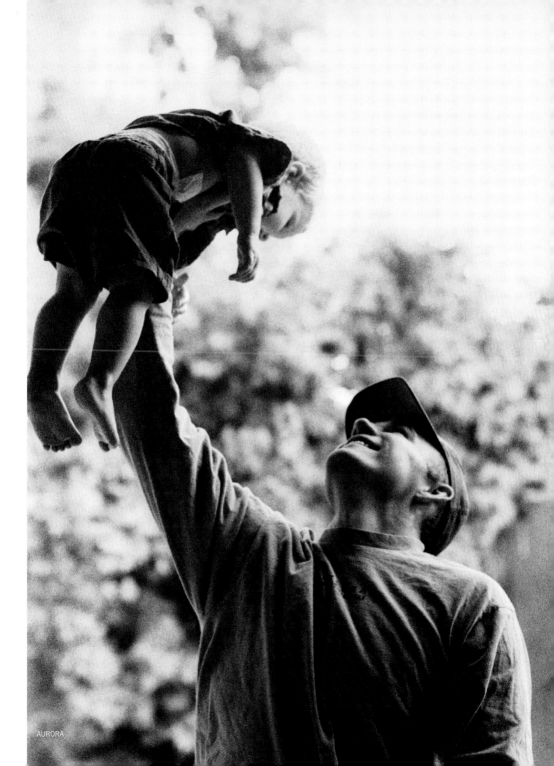

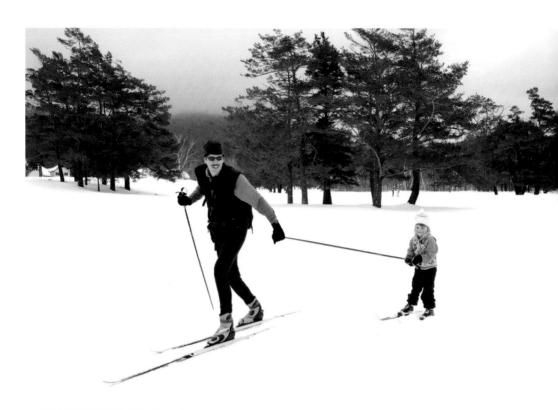

COLD FUN IN THE WINTERTIME
A father in Jackson, New Hampshire, does double duty
as he cross-country skis with his daughter.
Photograph by Tim Laman

HOT FUN IN THE SUMMERTIME
A pool in Half Moon Bay, California, offers this
moppet and her father a great way to cool down.
Photograph by Roy Toft

"If you instill in your child a love of the outdoors and an appreciation of nature, you will have given him a treasure no one can take away."

— Ted Trueblood, American outdoorsman and writer

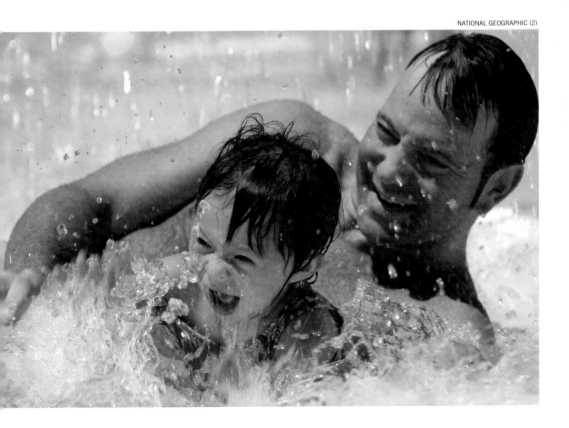

"Children will not remember you
for the material things
you provided but for the feeling
that you cherished them."
— Richard L. Evans, American radio announcer

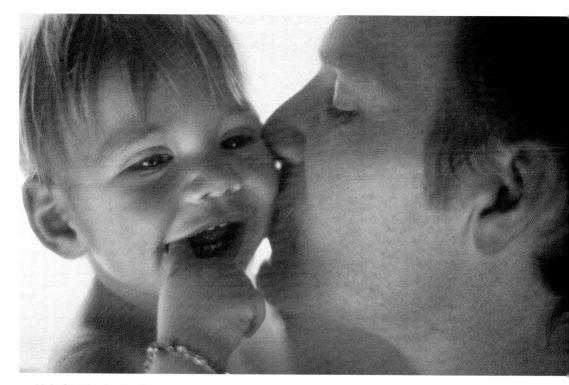

ALL SMILES NOW
Dylan Stork and his father, Mario, have reason to celebrate after Dylan's recovery from
a heart transplant operation. Twenty years and one more heart transplant later, Dylan is still
alive and well, and actively involved in charity causes.
Photograph by Alexander Tsiaras

CUPPA . . . MILK?
A young soldier in London's
Waterloo Station delights in feeding his baby.

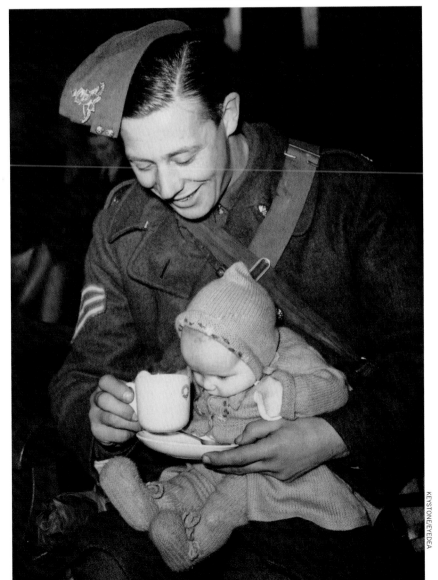

> "The joys of parents are secret, and so are their griefs and fears." — Francis Bacon, English philosopher

EARLY TO BED, EARLY TO RISE
In Fairfield, Idaho, rancher Greg Smith and his daughter, Georgia, take a working ride on their tractor.
Photograph by Dugald Bremner

THIS OLD HOUSE
Charles DeVries takes advantage of a fine June day in Schuyler, Nebraska, to reroof an old farmhouse, while his son, Ellery, watches intently.
Photograph by Joel Sartore

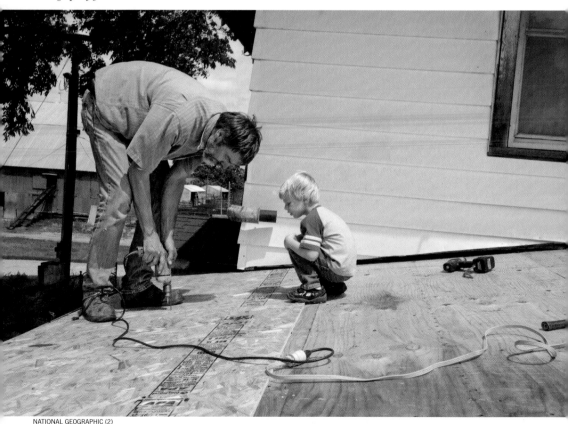

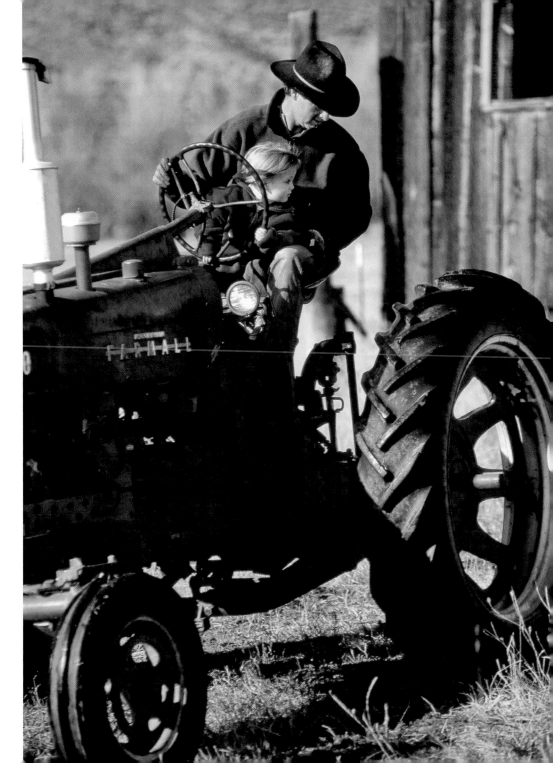

"Listen to your children at play. Their laughter will wash the years away from you." — Anonymous

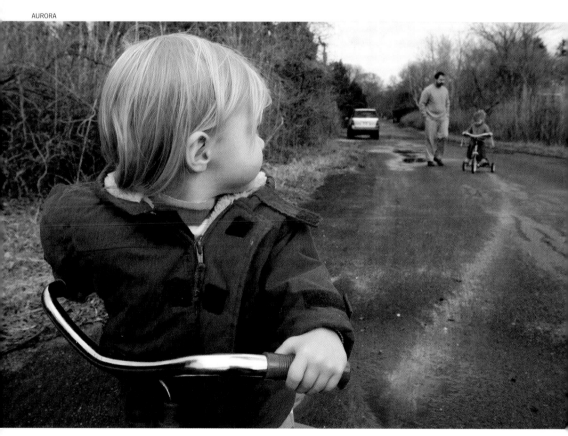

PEDAL POWER
This little girl has quickly pulled out ahead, but she can't help giving an anxious glance back at her father and sister.
Photograph by Gordon Grant

SLIP SLIDING AWAY
London's Hampstead Heath in winter offers a handy spot for sledding,
and this brother and sister are making good use of it with their father's help.

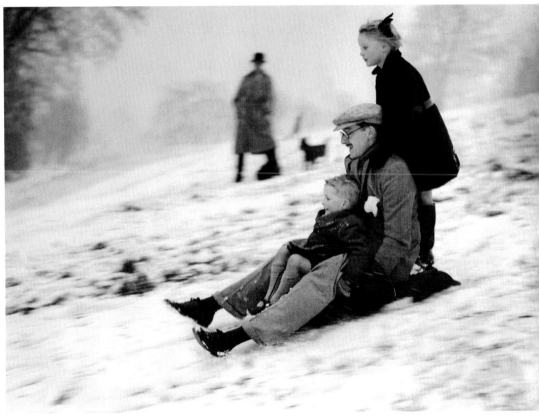

KEYSTONE/EYEDEA

> "The words that a father speaks to his children in the privacy of home are not heard by the world, but, as in whispering-galleries, they are clearly heard at the end and by posterity."
>
> — Jean Paul Richter, German writer

TEACH YOUR CHILDREN WELL . . .
Even with the water traffic and London's Tower Bridge behind them, John Doumin Brown and his stepdaughter Georgia Hedley are happily oblivious to everything around them.
Photograph by Russell Burrows

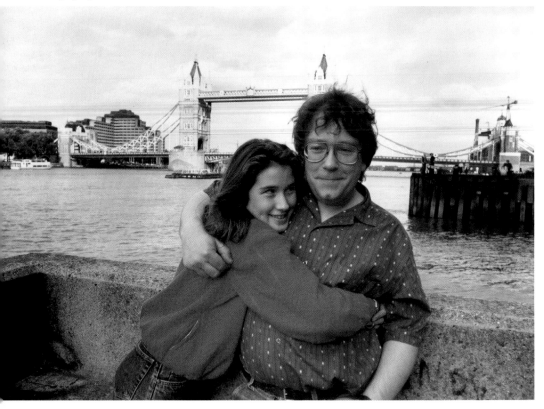

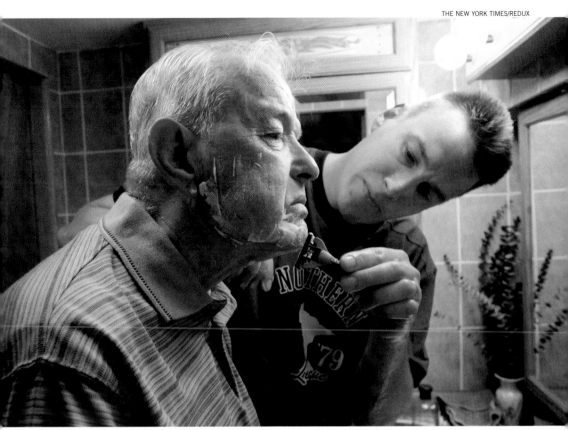

. . . AND KNOW THEY LOVE YOU
New York City Police Officer David Dillon takes his turn
in the family, caring for his disabled father, Christopher.

Photograph by James Estrin

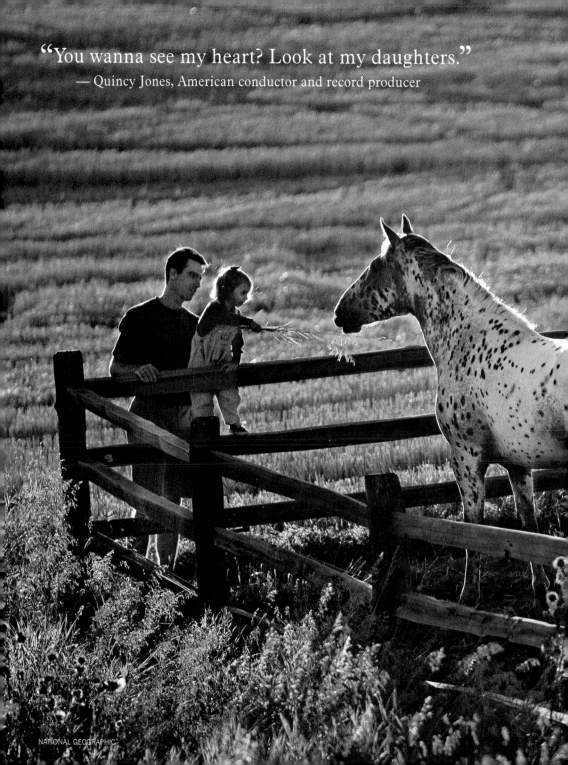

"You wanna see my heart? Look at my daughters."
— Quincy Jones, American conductor and record producer

MAKING FRIENDS
With her father's encouragement, a young girl offers a horse a tasty sprig
of grass on the grounds of the Appaloosa Museum in Moscow, Idaho.
Photograph by Michael S. Lewis

"I'm inspired by my own children,
how full they make my heart . . .
They make me want to be a better man."
— Barack Obama, 44th President of the United States

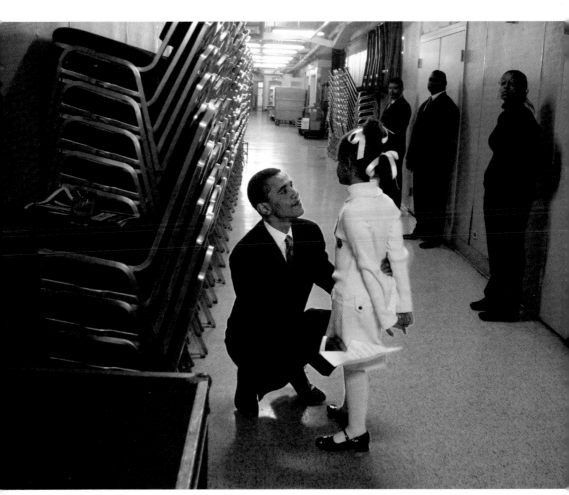

A PRIVATE MOMENT
Before a speech in Chicago, Obama consults with daughter Malia. These two,
along with Malia's mom and younger sister, have since relocated to Washington, D.C.
Photograph by David Katz